the declaration of
INTERDEPENDENCE

TARA CULLIS

DAVID SUZUKI

the DECLARATION

with

RAFFI CAVOUKIAN

WADE DAVIS

GUUJAAW

art by

MICHAEL NICOLL YAHGULANAAS

A Pledge to Planet Earth

of INTERDEPENDENCE

David Suzuki Foundation

GREYSTONE BOOKS
D&M PUBLISHERS INC.
Vancouver/Toronto/Berkeley

Greystone Books
An imprint of D&M Publishers Inc.
2323 Quebec Street, Suite 201
Vancouver BC Canada V5T 4S7
www.greystonebooks.com

David Suzuki Foundation
2211 West 4th Avenue, Suite 219
Vancouver BC Canada V6K 4S2
www.davidsuzuki.org

Library and Archives Canada Cataloguing in Publication
Cullis, Tara
The declaration of interdependence : a pledge to planet earth / Tara Cullis,
David Suzuki with Raffi Cavoukian, Wade Davis, Guujaaw;
art by Michael Nicoll Yahgulanaas.
Co-published by: David Suzuki Foundation.

ISBN 978-1-55365-546-6

1. Environmental protection.
I. Davis, Wade II. Guujaaw, 1953- III. Raffi IV. Suzuki, David, 1936-
V. Yahgulanaas, Michael Nicoll VI. David Suzuki Foundation VII. Title.
TD170.C86 2010 363.7 C2009-907020-0

Jacket and interior design by Heather Pringle
Jacket artwork by Michael Nicoll Yahgulanaas
Printed and bound in Canada by Friesens
Printed on acid free paper that is forest friendly
(100% post-consumer recycled paper) and has been processed chlorine free
Distributed in the U.S. by Publishers Group West

We gratefully acknowledge the financial support of the Canada Council for the Arts,
the British Columbia Arts Council, the Province of British Columbia through the
Book Publishing Tax Credit, and the Government of Canada through the Book Publishing
Industry Development Program (BPIDP) for our publishing activities.

Mixed Sources
Cert no. SW-COC-001271
© 1996 FSC
FSC

For Tamo, Midori, Jonathan, Ganhlaans—
"all those who will walk after us"
—who are our conscience and our inspiration

TARA CULLIS *and* DAVID SUZUKI

CONTENTS

the declaration of
INTERDEPENDENCE

THIS WE *know*

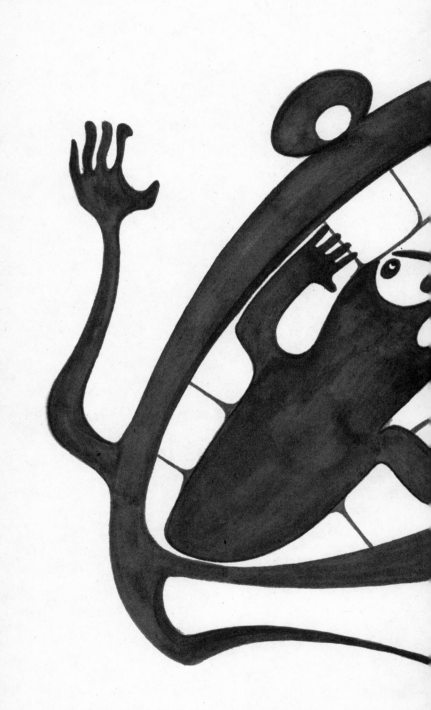

We are the earth,

through the plants and animals that nourish us.

We are the rains and the oceans

that flow through our veins.

We are the breath of the forests of the land,

and the plants of the sea.

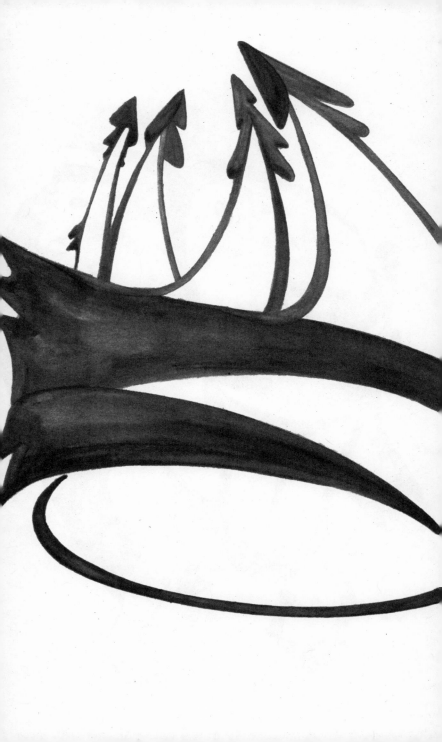

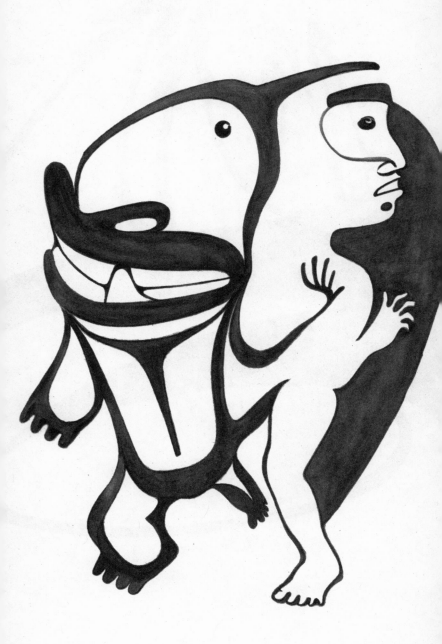

We are human animals,

related to all other life

as descendants of the firstborn cell.

We share with these kin a common history,

written in our genes.

We share a common present, filled with uncertainty.

And we share a common future, as yet untold.

We humans are but one

of thirty million species

weaving the thin layer of life enveloping the world.

The stability of communities of living things

depends upon this diversity.

Linked in that web, we are interconnected—

using, cleansing, sharing, and replenishing

the fundamental elements of life.

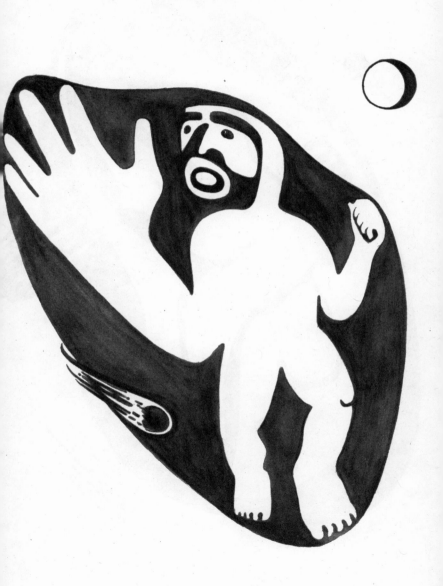

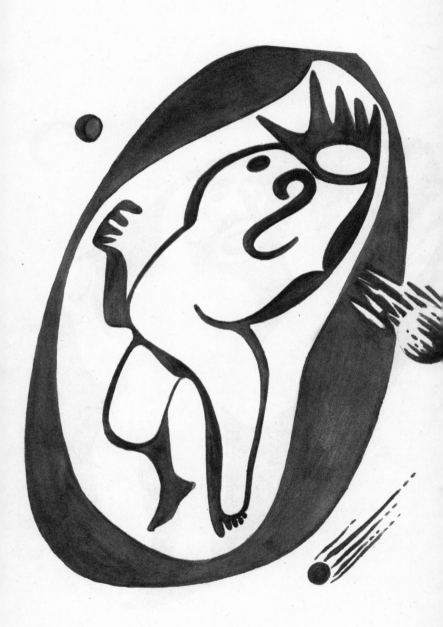

Our home, planet Earth, is finite;

all life shares its resources and the energy from the sun,

and therefore has limits to growth.

For the first time, we have touched those limits.

When we compromise the air,

the water, the soil, and the variety of life,

we steal from the endless future

to serve the fleeting present.

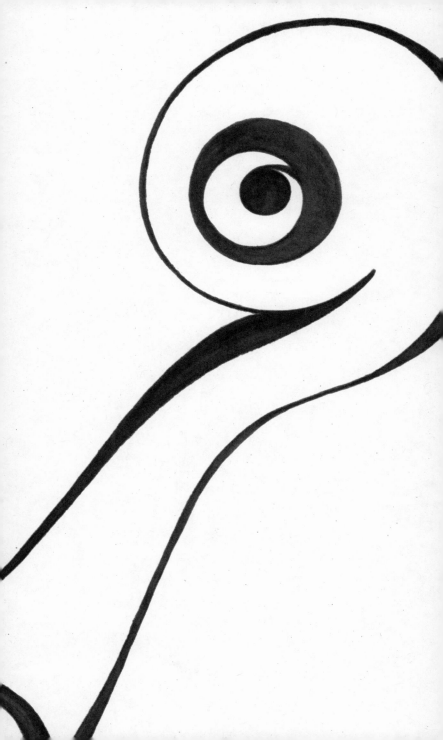

THIS WE *believe*

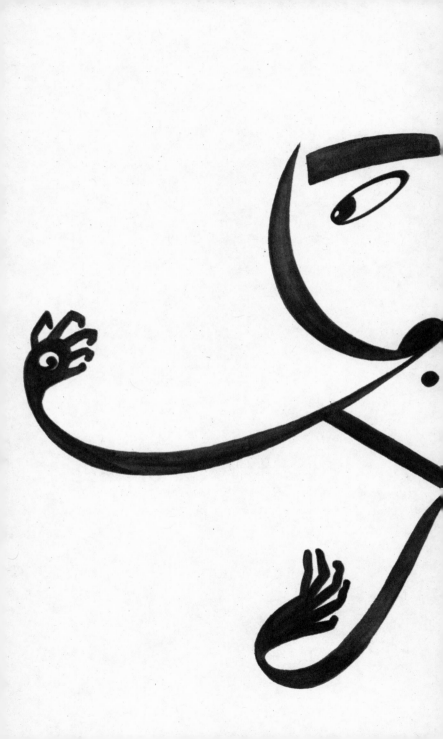

Humans have become so numerous

and our tools so powerful

that we have driven fellow creatures to extinction,

dammed the great rivers, torn down ancient forests,

poisoned the earth, rain, and wind,

and ripped holes in the sky.

Our science has brought pain as well as joy;

our comfort is paid for by the suffering of millions.

We are learning from our mistakes,

we are mourning our vanished kin,

and we now build a new politics of hope.

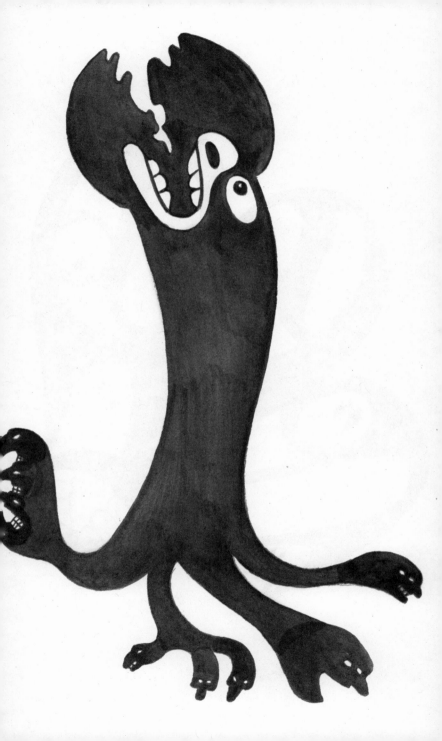

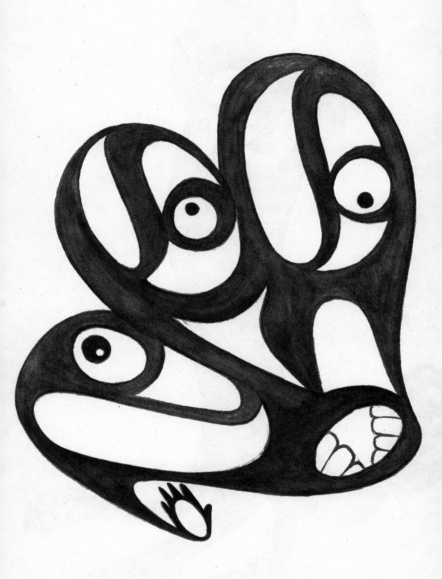

We respect and uphold the absolute need

 for clean air, water, and soil.

 We see that economic activities that benefit the few

while shrinking the inheritance of the many are wrong.

 And since environmental degradation

 erodes biological capital forever,

full ecological and social cost must enter all

 equations of development.

We are one brief generation in the long march of time;

the future is not ours to erase.

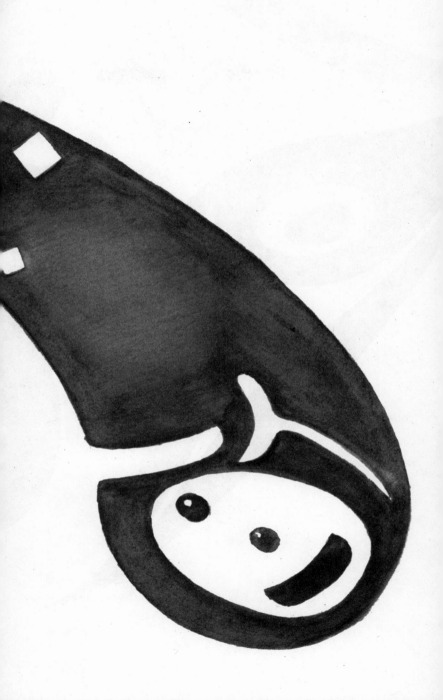

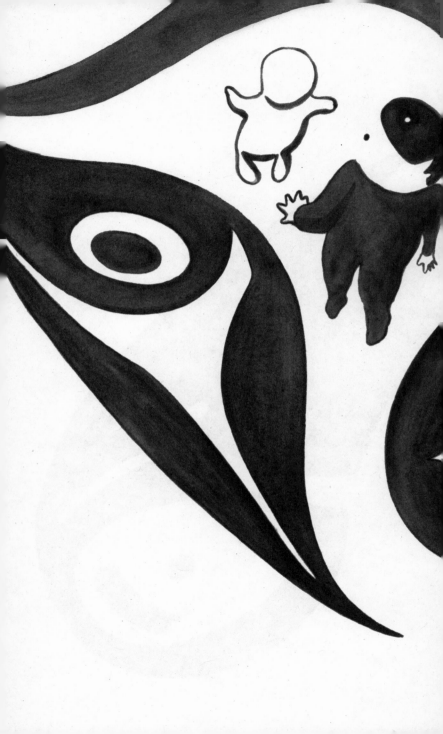

So where knowledge is limited,

we will remember all those who will walk after us,

and err on the side of caution.

THIS WE *resolve*

All this that we know and believe

must now become the foundation of the way we live.

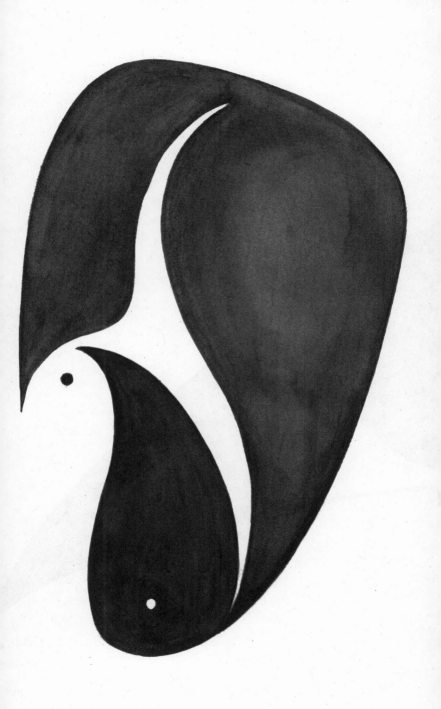

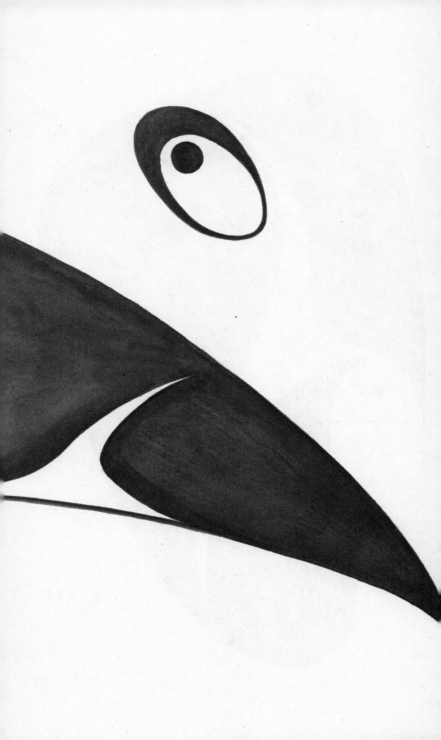

At this turning point in our relationship with Earth,

we work for an evolution:

from dominance to partnership;

from fragmentation to connection;

from insecurity

to interdependence.

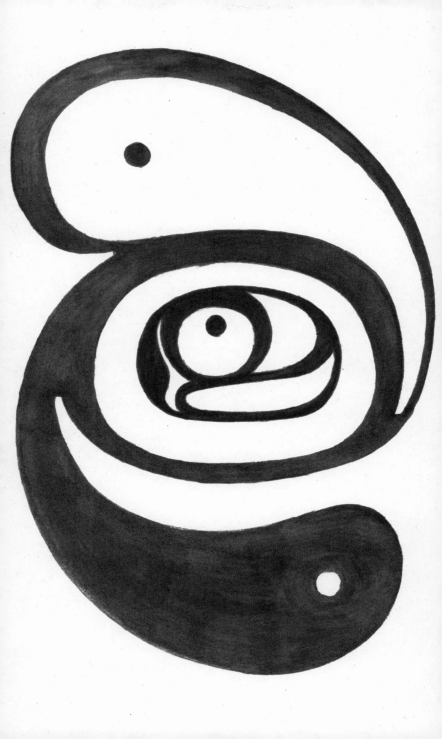

The Declaration of Interdependence

We are the earth, through the plants and
 animals that nourish us.

We are the rains and the oceans that flow
 through our veins.

We are the breath of the forests of the land,
 and the plants of the sea.

We are human animals, related to all other life
 as descendants of the firstborn cell.

We share with these kin a common history,
 written in our genes.

We share a common present, filled with
 uncertainty.

And we share a common future, as yet untold.

We humans are but one of thirty million species
 weaving the thin layer of life enveloping
 the world.

The stability of communities of living things
 depends upon this diversity.

Linked in that web, we are interconnected—
 using, cleansing, sharing, and replenishing
 the fundamental elements of life.

Our home, planet Earth, is finite; all life shares
 its resources and the energy from the sun,
 and therefore has limits to growth.

For the first time, we have touched those limits.

When we compromise the air, the water, the
 soil, and the variety of life, we steal from the
 endless future to serve the fleeting present.

THIS WE BELIEVE

Humans have become so numerous and our
tools so powerful that we have driven fellow
creatures to extinction, dammed the great
rivers, torn down ancient forests, poisoned
the earth, rain, and wind, and ripped holes
in the sky.

Our science has brought pain as well as joy; our
comfort is paid for by the suffering of millions.

We are learning from our mistakes, we are
mourning our vanished kin, and we now
build a new politics of hope.

We respect and uphold the absolute need for clean
air, water, and soil.

We see that economic activities that benefit the
few while shrinking the inheritance of the
many are wrong.

And since environmental degradation erodes
biological capital forever, full ecological
and social cost must enter all equations of
development.

We are one brief generation in the long march of
time; the future is not ours to erase.

So where knowledge is limited, we will remember
all those who will walk after us, and err on the
side of caution.

THIS WE RESOLVE

All this that we know and believe must now
 become the foundation of the way we live.
At this turning point in our relationship with
 Earth, we work for an evolution: from
 dominance to partnership; from fragmenta-
 tion to connection; from insecurity to
 interdependence.

The Origins of
The Declaration of Interdependence

DAVID SUZUKI
Founder, the David Suzuki Foundation

Human beings are an infant species, having appeared
on the plains of Africa only about 150,000 years
ago. We were upright, furless apes with few distin-
guishing traits, and there was little to indicate that
we would become the dominant species on Earth. Our
evolutionary advantage was hidden deep within our
skulls—a brain that gave us a prodigious memory,
curiosity, and inventiveness, which more than compen-
sated for our lack of physical and sensory prowess.

For most of human existence, we were a local, tribal
animal. We didn't worry about people on the other side
of the ocean, mountain range, or desert. We lived in
our tribal territory and cared for our own people. Then,
in the last century, we suddenly became a new kind
of force, a species that has transformed the chemical,
physical, and biological makeup of the planet on a
geological scale. In four billion years of life's existence
on Earth, there has never been a single species capable
of what we are doing now, and that ability was acquired
in the last moment of cosmic time.

Humans are now the most populous mammal on Earth. Our sheer numbers mean that we have an enormous ecological footprint—the amount of land and water needed to fulfill our basic needs. But our impact is far in excess of what is required to meet those needs. We use a huge amount of technology to provide food, clothing, shelter, workplaces, transportation, and so on, and those technologies allow us to increase our demands beyond those made by any other species. It doesn't end there. We have become afflicted with a huge appetite for Stuff—we are super-consumers. This consumptive demand is fed by a global economy that exploits the entire planet as a source of raw materials and seeks to use the entire global population as a market for its goods. When we add these together— our numbers, our technological muscle power, our consumptive appetite, and the global economy—we can see why our impact is so immense.

At the beginning of humanity's time on Earth, there were not so many people, and nature seemed vast and endlessly self-renewing. But today, as we clear the forests, eliminate species, and dump our waste and toxic material into the air, water, and soil, we are undermining the productivity of nature itself. For the first time we have to ask, "What is the collective impact of 6.7 billion human beings living on the planet?"

For most of our existence, human beings were aware that we are deeply embedded in and utterly

dependent on nature for our survival and well-being. Even in 1900, with close to two billion people in the world, only fourteen cities had a population of more than a million. Most people on the planet lived in rural village communities. We were farmers. Farmers understand that we are dependent on the vagaries of weather and climate (winter snows are related to moisture in the soil in the summer), that not all insects are pests (some are important vectors of pollination), and that all wild plants are not weeds (some take nitrogen from the air and fix it in the soil as fertilizer). Farmers know we depend on and must work with nature.

Only a hundred years later, in 2000, the global population had risen threefold to six billion, and the number of cities with over a million people had increased to more than three hundred. Most people, especially in industrialized countries, live in big cities, where it becomes easy to believe that our highest priority must be the economy. Ask an urban child about the source of his or her drinking water or electricity or food; ask what happens when we flush a toilet or put garbage on the curb. Most won't know the answer. It is easy to assume our leaders in business and government are correct when they say the economy is the source of everything we need—the products, the garbage collection and sewage treatment, the plentiful electricity and clean water. Most don't understand that every single thing we use comes from the earth and goes back to it as waste.

We hear it all the time. I was told by a minister of the
environment from Alberta that "we can't afford to
protect the environment without a strong growing
economy." Even a minister of the environment thinks
his highest priority is ensuring economic growth.
Like the Bush administration in the United States and
Australia's then prime minister, John Howard, the
prime minister of Canada set the economy above other
concerns as he informed Canadians that we cannot even
try to achieve the targets of the Kyoto Protocol (even
though we had agreed to it as a nation) or do anything
to reduce greenhouse gases, because it would "ruin the
economy." Coming from the most powerful person in
the country, this philosophy is doubly egregious. First,
it is simply not true. Sweden, a northern country like
Canada, put a price on carbon with a carbon tax in the
1990s and has reduced its greenhouse gas emissions
to 8 per cent below 1990 levels while its economy has
grown by 44 per cent. Second, leading economists like
Sir Nicholas Stern of the U.K. inform us that a warmer
world will be catastrophic to the economy, costing more
than World Wars I and II combined and plunging us
into an economic depression beyond anything we've
ever experienced or imagined.

The environmental movement is a young one,
whose conception I attribute to Rachel Carson's
pioneering book, *Silent Spring*. Published in 1962, this
book documented the unexpected effects of DDT and

other chemical pesticides. Suddenly the world became aware that there were hidden costs to our intellectual and technological prowess. In 1962 there wasn't a single "department of the environment" in any government on the planet. The word "environment" didn't mean what it does today. Carson's book was read by millions around the world, and it generated a massive response. I, and millions of others, began to look at the world differently. We could see the problems our powerful technologies and consumptive demands were causing, and we became aware of the consequences of using the entire planet as a dump for our wastes. In British Columbia, the first issue I saw through an environmental lens was the American plan to detonate underground nuclear devices in Amchitka, off the tip of Alaska. Many of us feared this would trigger tidal waves or earthquakes or vent a cloud of radioactive gases. The U.S. government paid no heed to the objections.

British Columbia was also dealing with other issues—clear-cut logging in the temperate rain forest, a proposed dam on the Peace River, oil drilling in the treacherous waters of Hecate Strait, and pollution from pulp mills. We were removing too many resources from our environment while putting too much waste and toxic material back. In addition to protesting, some of us lobbied for laws and the infrastructure to enforce them. In my mind, the solution was to set up ministries of the environment that would develop regulations to ensure clean air, clean water, and species protection, and be responsible for enforcement.

By the early 1970s, I realized that our ignorance was vast and that we would never be able to regulate all of the powerful new technologies. When DDT was recognized as an insecticide, scientists didn't know about biomagnification—the process whereby deadly concentrations are amplified up the food chain. This phenomenon was only discovered when eagles began to disappear in the United States and biologists eventually traced the source of the problem to DDT. When atomic bombs were dropped on Japan in 1945, scientists didn't know about radioactive fallout, electromagnetic pulses of gamma rays that knock out electrical circuits, or nuclear winter. When we used millions of pounds of CFCs, we had no idea that in the upper atmosphere ultraviolet light would break chlorine free radicals off the CFCs and that chlorine would break down ozone. When the effect of CFCs on the ozone layer was first announced, my response was, "What ozone layer?" And now, genetically modified organisms are being grown around the world with very little understanding of the long-term consequences of creating novel combinations of genes and releasing them into the environment.

A Different Perspective

We are in the midst of a huge crisis. We need more science to inform us about how the world works. And since we know so little, how can we be sure that applications of our incomplete knowledge will not have completely unexpected and deleterious effects?

There is a way out. Nature has had four billion years to experiment with ways of solving the same kinds of problems we now face, such as how to find food, how to keep from getting eaten, where to get energy, how to recover from illness. Rather than bludgeoning nature into apparent submission with our powerful technologies, we can approach it with greater humility. We can ask how nature has solved problems and what we can learn from those solutions. Janine Benyus coined the term "biomimicry" to explain this new approach, and although there is no guarantee we won't still have problems if we copy nature, I believe it will be far less likely.

In the late 1970s I became aware of a battle over forests and logging that had been raging for years in the islands off the tip of the Alaskan panhandle, called Haida Gwaii by its original inhabitants. I flew to the islands to interview forestry executives, environmentalists, politicians, and the Haida people. Guujaaw, a young Haida artist, had led the battle against logging for years. But the forest industry employed many Haida, who desperately needed economic opportunities. Why fight logging, then? I asked what would happen if the logging continued and the entire island archipelago was deforested. Guujaaw answered, "Then I guess we'll be like everybody else." A simple yet incredibly profound statement. Guujaaw opened the window on a radically different way of seeing the world. He was saying that to be Haida means to be connected to the land; the Haida's connection to air, water, fish, trees,

and birds is what makes Haida special, and without that connection they become like the rest of society.

Since then, I have met Aboriginal people in different parts of the world and encountered that same connection to nature and the land. Aboriginal people refer to Earth as their Mother and speak of the four sacred elements: Earth, Air, Fire, and Water. They have totems and clans based on other species—fireweed, cedar, killer whale, wolf, eagle, and raven. To Aboriginal people, these other species are not merely resources or commodities, but our relatives.

As I contemplated these lessons, I realized we had framed the environmental problem incorrectly. We *are* the environment. There is no separation; there is no environment "out there" that we have to regulate our interaction with. Air is in us and circulates throughout our bodies at all times, we are made up of more than 60 per cent water by weight, we are built by the molecules in the food we consume—most of which has come from the earth—and every bit of the energy that we need to grow, move, and reproduce is the fire of the sun captured by plants through photosynthesis. We are the earth, and so whatever we do to it, we do directly to ourselves.

The Turnaround Decade and
the Declaration of Interdependence

Since Carson's book, environmental issues have become major social and economic concerns—clear-cut logging, toxic pollution, massive oil spills, endangered

species—that occupy increasingly more time and space in the media. Ten years after *Silent Spring*, in 1972, a U.N. conference on the environment in Stockholm led to the formation of the United Nations Environment Programme. But despite the phasing out of CFCs, the cross-border agreements to reduce acid rain, and the legislation for clean air, clean water, and biodiversity, ecological issues proliferated and worsened. By 1988, global concern had made the environment the highest priority; Margaret Thatcher declared she was a "greenie," while George H.W. Bush promised, if elected, to "be an environmental president."

In 1990, the Worldwatch Institute in Washington, D.C., labelled the 1990s "The Turnaround Decade," in which we would have to make significant changes to the way we interacted with the planet. That year, with that challenge resonating, we opened the doors of the David Suzuki Foundation.

In 1992, environmentalists around the world anticipated the largest gathering of heads of state in history at a meeting in Rio de Janeiro. The Earth Summit was meant to ensure that henceforth all human actions would include a consideration of environmental consequences. The David Suzuki Foundation was a new organization with a small, all-volunteer staff. We wanted to make a contribution to the Summit, but what could it be? I believed we needed to move away from our anthropocentric focus—our belief that human beings are the centre of everything and that everything we do must be measured according to human

consequences and economics. We needed to help people see the world differently, to look through the perceptual lens of biocentrism, recognizing that we are part of a community of organisms sharing the same biosphere, dependent on each other for our survival and well-being.

We began to think about a statement—a declaration that might convey this profound perspective. We set about crafting a document that would address the issues that concerned us. Taking a cue from the American Declaration of Independence, Tara Cullis suggested we call ours the Declaration of *Inter*dependence. Tara and I worked as a team, scribbling down sentences that expressed what we felt were the critical issues. We wanted the document to be uplifting and poetic, something that would capture people's emotions and move them to action. I was overwhelmed by the lessons I had learned from Guujaaw, and I wanted to include this new insight. I wrote, "We are made up of the food we eat, the water we drink, the air we breathe." It was clumsy, but it contained the essence of what I had learned. But then I remembered: it's not "we are *made up of. . .*" It's "we *are* the earth."

We knew we needed different perspectives and expertise, so we invited others to contribute. We asked Guujaaw, who had opened my eyes to a new way of seeing. We engaged Raffi, the internationally renowned children's singer, who provided critical elements with a child's perspective in mind. We brought in Wade Davis, an eminent ethnobotanist and author whose profound

and evocative writing grows out of his vast experience with indigenous peoples around the world. They each provided invaluable wisdom. We knew that crafting any work by committee presents a challenge, but we were committed to incorporating all of the voices.

We completed the Declaration in time for the Rio Summit. After reviewing it with colleagues, we had the final version translated into five languages—French, German, Russian, Japanese, and Mandarin. The Declaration of Interdependence—our formal contribution to the Earth Summit conference—is the David Suzuki Foundation's call to action and our prayer for the continuation of life on Earth. It has become a lasting statement to guide the Foundation in all of its activities.

The David Suzuki Foundation

TARA CULLIS
Co-Founder and President, the David Suzuki Foundation

The 1980s were a decade of ferment and growth in the global environmental movement. High-stakes battles erupted in Canada and around the world, while Aboriginal leaders brought a new perspective to environmental thinking and began connecting across the continents.

Battles were won, but the war was being lost. In 1989 David Suzuki's award-winning radio series *It's a Matter of Survival* sounded an alarm, starkly summarizing where the planet was heading. Seventeen thousand of his shocked listeners mailed letters to David with urgent requests for solutions to avert the catastrophe. A group of people we respect urged us to create a new, solutions-based organization.

That November, David and I hosted a two-day gathering with a dozen thinkers and activists on Pender Island, one of the southern Gulf Islands of British Columbia. Existing groups were working hard on the crises, and we hoped they could buy us time to explore in more depth ways to extinguish the source of these

brush fires. By the end of the weekend we knew something significant was afoot. Meetings went on all winter and spring. And on September 14, 1990, the David Suzuki Foundation was incorporated.

Our early projects were international because our meagre project dollars could go much further overseas, leaving us funds to develop a solid infrastructure at home and time to undergo a thorough planning process for our Canadian projects. We worked with the Ainu of Japan to protect their salmon and with OREWA (the Embera and Wounaan Regional Indigenous Organization) in Colombia. We worked with the Kayapo people of Brazil to open the first research station in the lower Amazon, part of a process that preserved the largest tropical forest protected by a single indigenous group (28.4 million acres/11.5 million hectares) in the world. We commissioned research on a dam project in Australia and worked with the Hesquiat people of Vancouver Island to restore a clam fishery. With each of these projects, we partnered with local peoples to develop alternative models of economic and community development. We were working to balance human needs with Earth's ability to sustain life, and our ambitious goal was—and is—to find and communicate practical ways to achieve that balance.

We needed a synopsis of our philosophy—a creed, a call to arms. The Declaration of Interdependence gives voice to our guiding principles and underlies our decisions and our actions. People say you can't write by committee. It's not true. This document went the

rounds of all the authors many times and, remarkably, became more eloquent with each rewrite. At the Earth Summit in Rio, portions of our declaration were woven into the work of others around the world to form the Earth Charter, whose adherents are still growing.

We learned from the best how to fundraise, gradually building our core group of committed donors, many of whom remain our enthusiastic partners today. Their faith allowed us to dive into our locally based work, which we started by holding a well-attended conference for all NGOs on how to effect social change and by publishing the proceedings as "Tools for Change." Next we launched our explorations into sustainability with "Living within Our Means." Then we began working on forestry with "Chopping Up the Money Tree." We discussed the problems with the fisheries in "Fish on the Line" and then presented solutions from around the world in "Fisheries That Work." Fisheries was also the subject of our first book, *Dead Reckoning*, by Terry Glavin. Our second was *The Sacred Balance*, by David Suzuki. We have now published almost forty books, all in partnership with Greystone Books.

By 1996, we had ramped up our work on climate change, quickly publishing five reports in the run-up to the Kyoto Conference in 1997, where we worked hard to influence events. How frustrating it was to settle for such a low bar in the Kyoto Protocol. (Little did we know that Canada would not even meet Kyoto's low standards.) On Earth Day 1997 we partnered

with the local Musqueam First Nation to launch the Musqueam Watershed Restoration Project, working to bring the last salmon stream in Vancouver back to health. Meanwhile, our work in forestry and fisheries combined in the launch of the ambitious Salmon Forest Project, which worked with the communities of the B.C. central and northern coast and Haida Gwaii to form the powerful coast-wide alliance now known as the Coastal First Nations Turning Point Initiative. The members of this group are the crucial players in the Great Bear Rainforest.

We went on to publish landmark guidelines for ecosystem-based management (EBM) of logging and exposés of the overharvesting of cedar. We also produced exhaustive annual report cards on the status of Canadian rain forests, including the size of clear-cuts and the treatment of salmon streams, old growth, and bear habitat. In fisheries we funded Dr. Tom Reimchen's research, which revealed the startling role of salmon in fertilizing the growth of the great trees of the West Coast watersheds and thereby their whole ecosystem. We began work to protect species at risk; we helped governments ban pesticides. We commissioned research into the contaminants in farmed salmon, exposed the escapes of Atlantic salmon into Pacific waters, litigated against the dumping of dead fish by fish farms, and challenged gravel extraction in the Fraser River. We funded the Leggatt Inquiry into Salmon Farming, toured the coast in support of the tanker moratorium, and worked, as we continue to do, with the top chefs of

British Columbia and Ontario to switch their clientele to sustainable seafood.

Our Climate Change team expanded into the health arena with powerful results, working with doctors across the country to fight for clean air, while publishing alternative energy solutions and lobbying successfully at long last for Canada to sign the Kyoto Protocol. Canada's endorsement set the stage for Russia to agree to sign it, and Kyoto became international law in February 2005. And we were proud. We brought the voices of Olympic skiers and NHL hockey players into the call for carbon neutrality and worked with the governments of British Columbia, Manitoba, Ontario, and Québec to support renewable energy and the carbon tax. In 2009 we published a widely hailed report showing that Canada can meet the necessary greenhouse gas targets without compromising the economy.

People told us they want practical steps to sustainability in their own lives. So we developed the Nature Challenge and toured the country with speeches and entertainers, culminating in a Discovery Channel TV special. We expanded it to the Nature Challenge for Kids (NC4K), now in use in school curricula, and the Nature Challenge at Work, used by many corporations. We moved into gardening with David Suzuki Digs Your Garden and into households through our Queen of Green and her recipes for everything from laundry soap to green weddings.

Abroad, we used our long experience in the Amazon, the B.C. coastal rain forest, and the Musqueam

watershed to teach conservation planning in the Four Great Rivers region of southeastern Tibet, where we successfully worked with the group Future Generations to protect a massive area of mountains and forest the size of Italy—headwaters of the Brahmaputra, the Yangtze, the Mekong, and the Salween, whose waters nourish a third of the people on this planet.

We moved into economics, assessing the true value of greenbelts, farmland, pollination, and other ecosystem services. We published a widely read international guide to businesses working to shrink their footprint, and we are opening a centre for ecological economics in Toronto.

By 2004 we had developed our umbrella strategy, Sustainability within a Generation (SWAG), a blueprint showing how Canada can reach sustainability—within a reasonable time frame of twenty-five years. The deadline energizes us and releases our creativity. The challenges facing us are daunting, but they can be overcome.

Today we are bilingual, with a busy office in Montreal, as well as a small staff in Ottawa and Toronto in addition to our original Vancouver office. Our goals are to protect climate, protect and reconnect with nature, transform the economy into one that is sustainable, and build community—so that we can all live healthier, more fulfilled, and just lives. We are working with communities, businesses, and governments to find ways for people and societies to exist in balance with the natural world. And we are working with the thousands of other individuals and groups

who share the principles expressed in this Declaration to help build a great movement, a vast community that understands that although individual actions seem small, together they change the world.

Twenty years after that first Pender Island meeting, seventeen years after the writing of the Declaration of Interdependence, the David Suzuki Foundation has become a strong and capable force. Grassroots donors, a talented and determined staff, and committed volunteers have made the Pender Island dream of 1989 a reality. May the Declaration of Interdependence inspire us to make the next twenty years historic: may we witness the birth of the greatest turnaround humankind has ever seen.

TARA CULLIS is an award-winning writer and President and Co-founder of the David Suzuki Foundation. She has been a key player in environmental movements in the Amazon, Southeast Asia, and British Columbia. Dr. Cullis has been adopted and named by the Haida, the Gitga'at, the Heiltsuk, and the 'Namgis First Nations.

Award-winning geneticist and broadcaster DAVID SUZUKI has written more than forty books and is a world leader in sustainable ecology. For his support of Canada's First Nations people, Dr. Suzuki has been honoured with six names and formal adoption by two tribes. He was awarded the 2009 Right Livelihood Award in recognition of his long commitment to raising awareness of climate-change issues.

WADE DAVIS is a noted anthropologist, ethnobotanist, author, filmmaker, and photographer whose work has focused on worldwide indigenous cultures, especially in North and South America. Currently Explorer-in-Residence with National Geographic, Davis has been described as a "passionate defender of all of life's diversity."

GUUJAAW is a singer, carver, traditional medicine practitioner, and president of the Haida Nation of the Pacific Northwest coast. His love for the land and understanding of the vulnerability of life has led him to devote much of his life to fighting the forces that are damaging the planet.

RAFFI CAVOUKIAN, C.M., is a renaissance man known to millions simply as Raffi: a renowned Canadian troubadour, music producer, systems thinker, author, entrepreneur, ecology advocate, and founder of Child Honouring. *www.raffinews.com*

MICHAEL NICOLL YAHGULANAAS'S art is informed by years of political activism, mostly on behalf of the Haida. His work—including "Haida manga," the distinctive art form for which he is widely known—riffs on traditional techniques. Yahgulanaas has devoted much of his life to working with other Haida people to prevent their homeland from being logged. *www.mny.ca*

The David Suzuki Foundation

The David Suzuki Foundation works through science and education to protect the diversity of nature and our quality of life, now and for the future.

With a goal of achieving sustainability within a generation, the Foundation collaborates with scientists, business and industry, academia, government, and non-governmental organizations. We seek the best research to provide innovative solutions that will help build a clean, competitive economy that does not threaten the natural services that support all life.

The Foundation is a federally registered independent charity that is supported with the help of over 50,000 individual donors across Canada and around the world.

We invite you to become a member. For more information on how you can support our work, please contact us:

The David Suzuki Foundation
219–2211 West 4th Avenue
Vancouver BC Canada V6K 4S2
www.davidsuzuki.org
contact@davidsuzuki.org
Tel: 604-732-4228
Fax: 604-732-0752

Cheques can be made payable to The David Suzuki Foundation. All donations are tax-deductible.

Canadian charitable registration:
(BN) 12775 6716 RR0001
U.S. charitable registration: #94-3204049

Recent titles from
The David Suzuki Foundation and Greystone Books

The Big Picture: Reflections on Science, Humanity, and a Quickly Changing Planet by David Suzuki and Dave Robert Taylor

David Suzuki's Green Guide by David Suzuki and David R. Boyd

A Good Catch: Sustainable Seafood Recipes from Canada's Top Chefs by Jill Lambert

Lakeland: Journeys into the Soul of Canada by Allan Casey

The Sacred Balance: Rediscovering Our Place in Nature by David Suzuki, Amanda McConnell, and Adrienne Mason

Tar Sands: Dirty Oil and the Future of a Continent by Andrew Nikiforuk

Wisdom of the Elders: Native and Scientific Ways of Knowing about Nature by Peter Knudtson and David Suzuki